This Notebook belongs to:

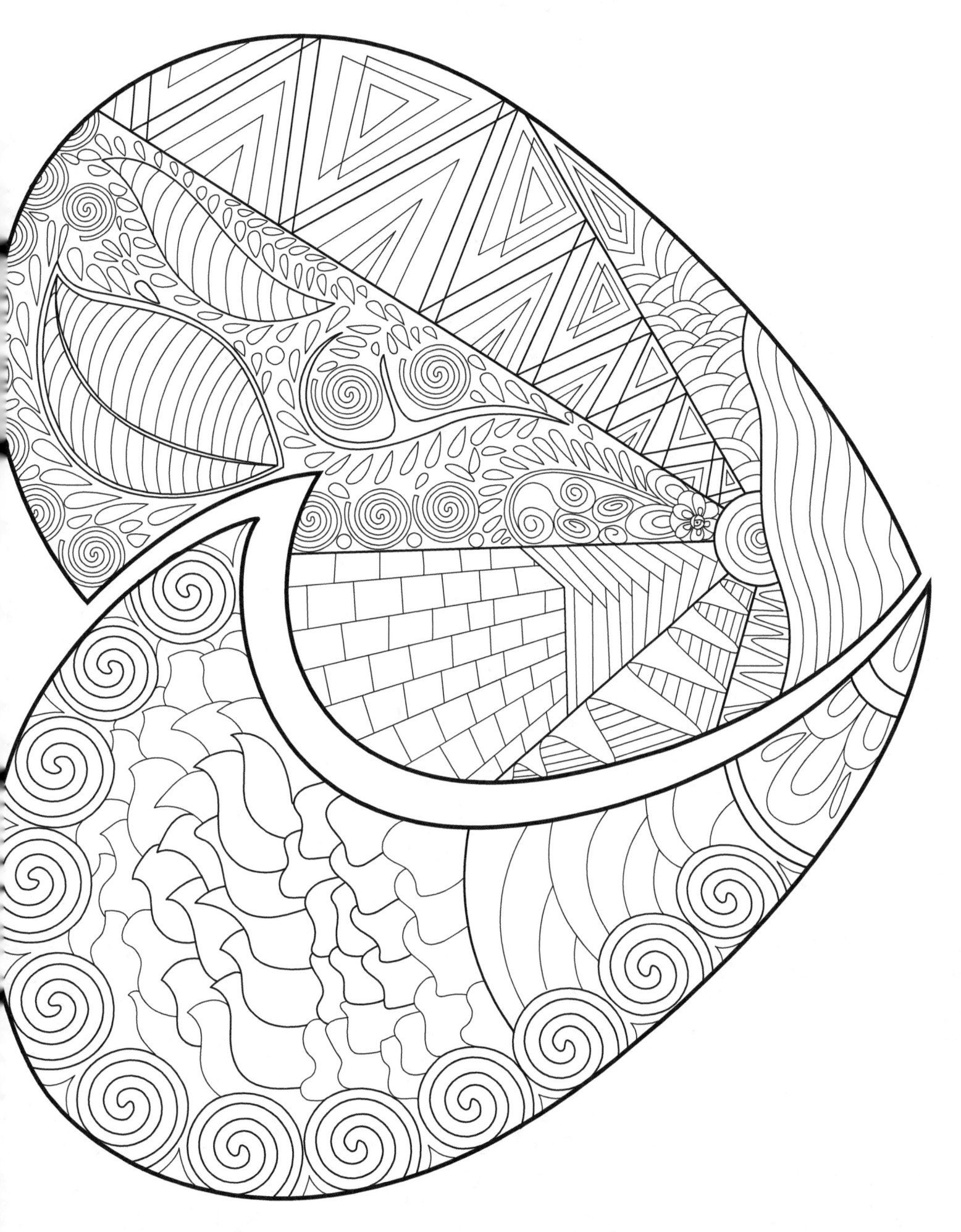

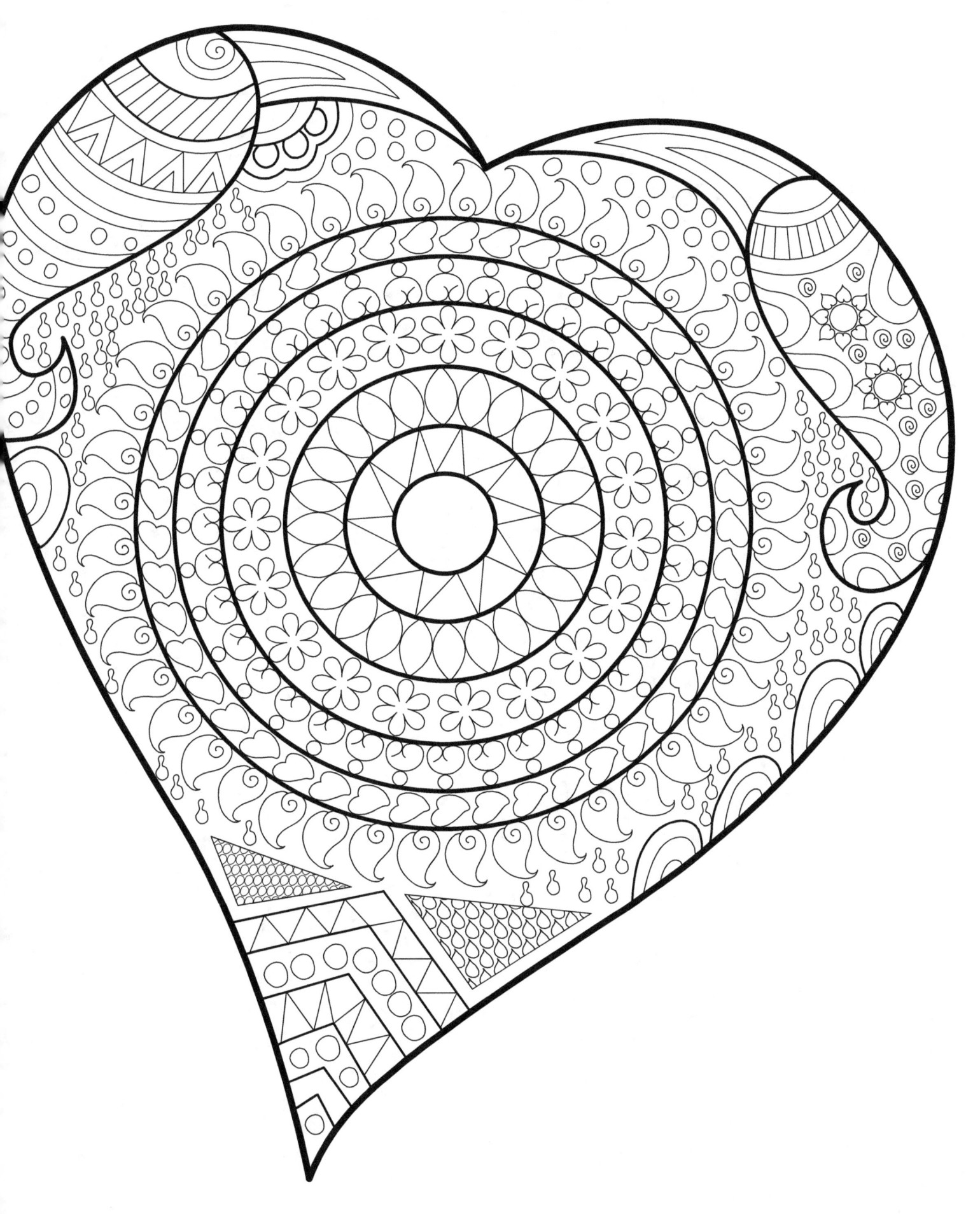

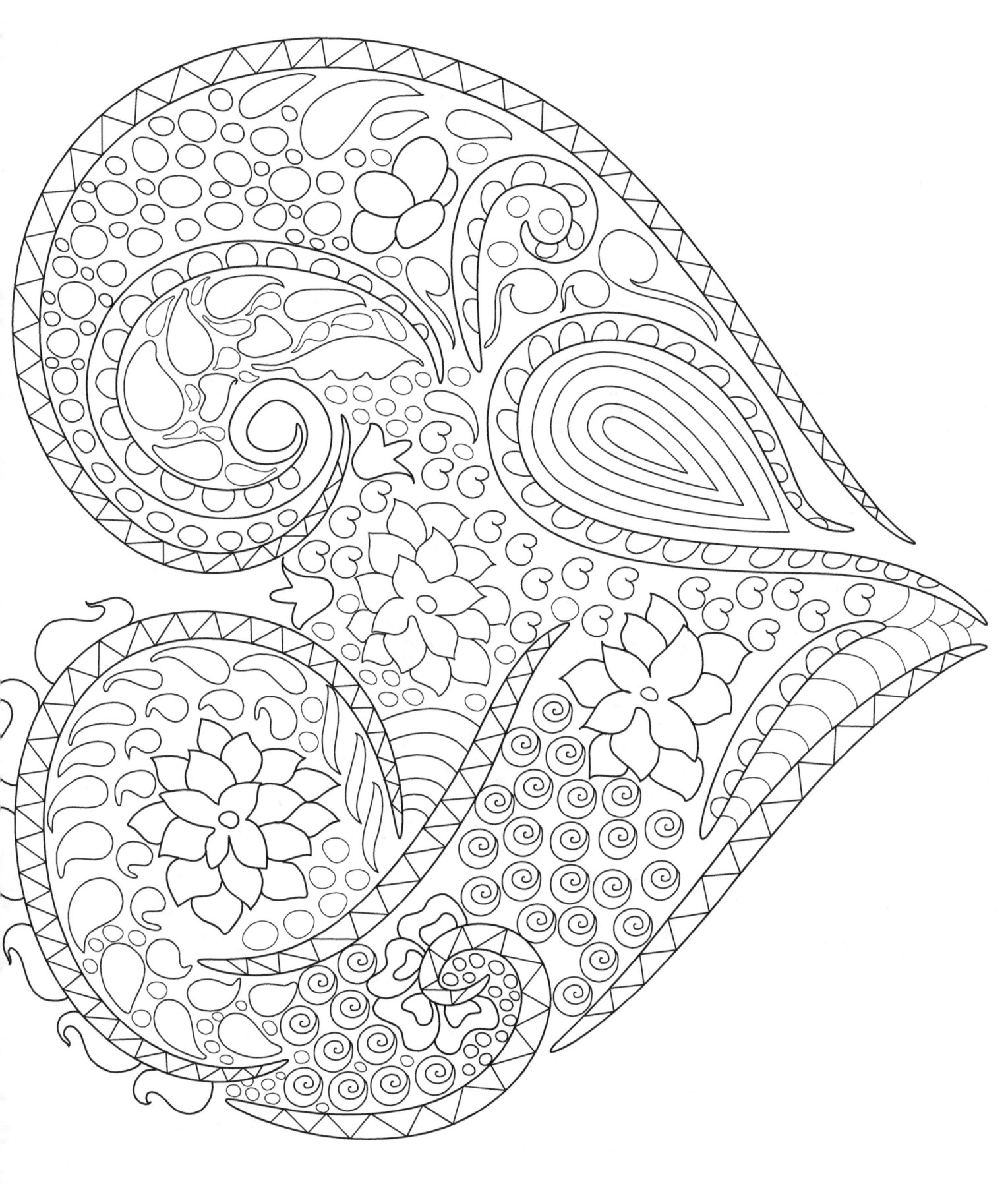

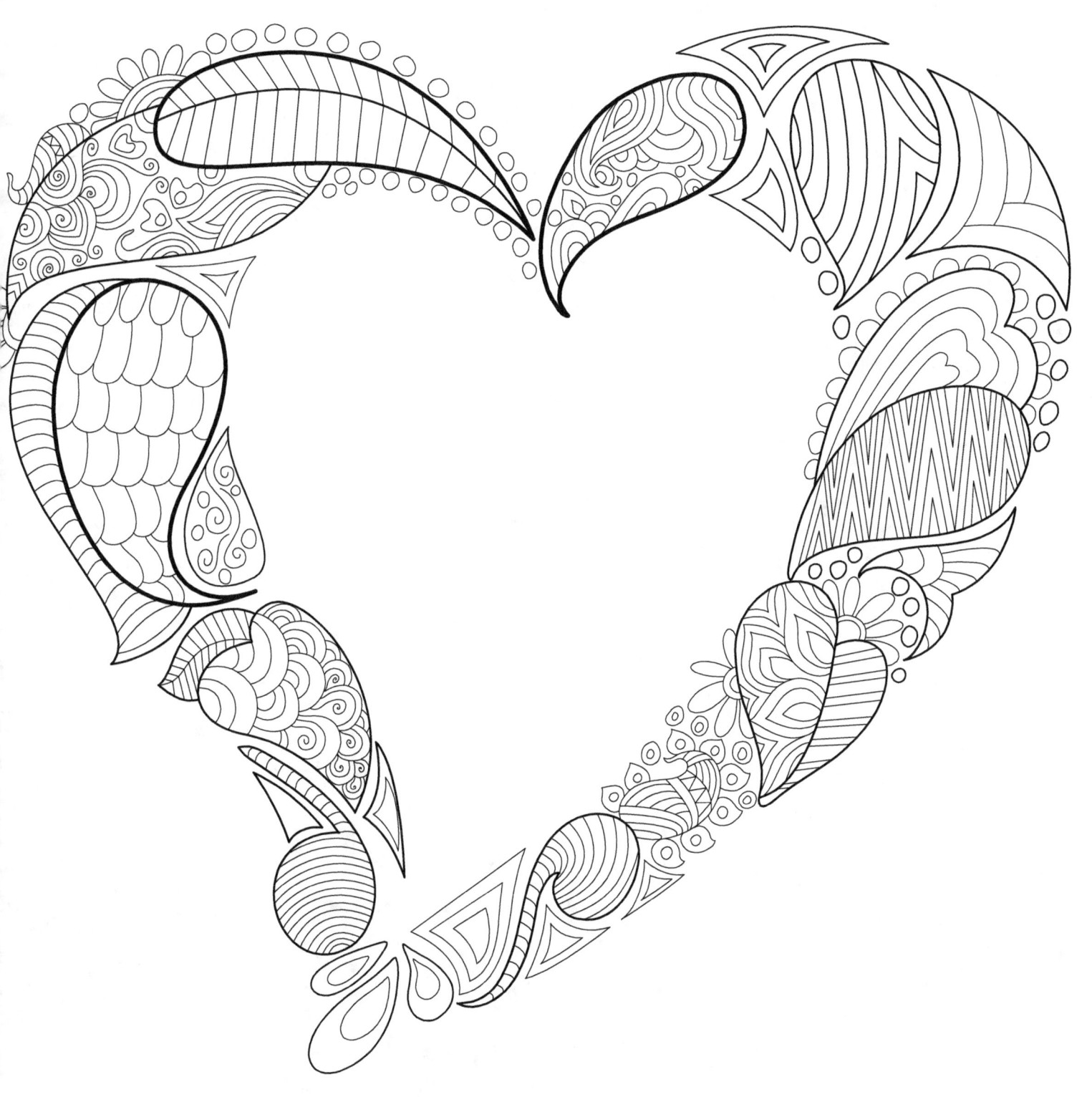

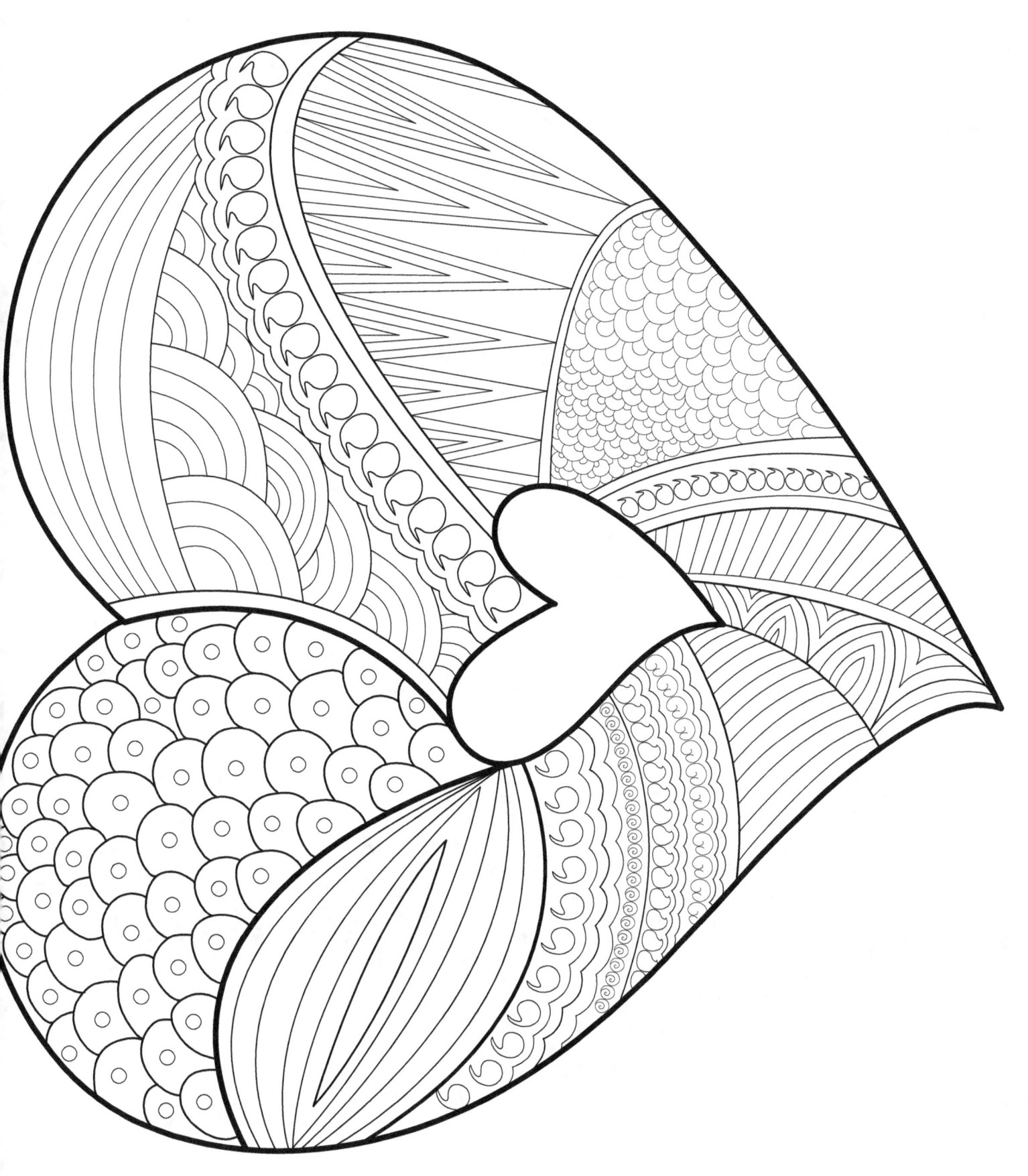

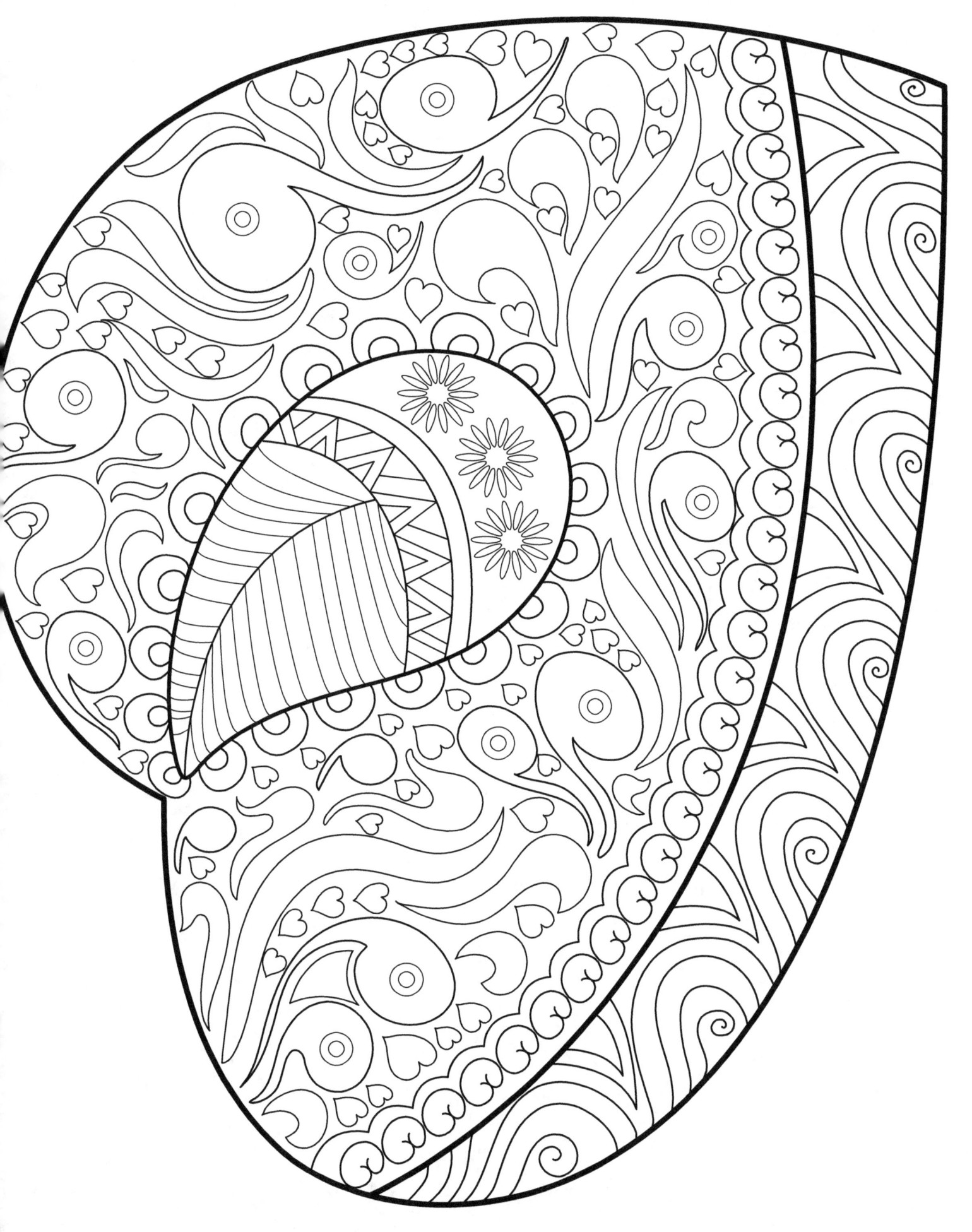

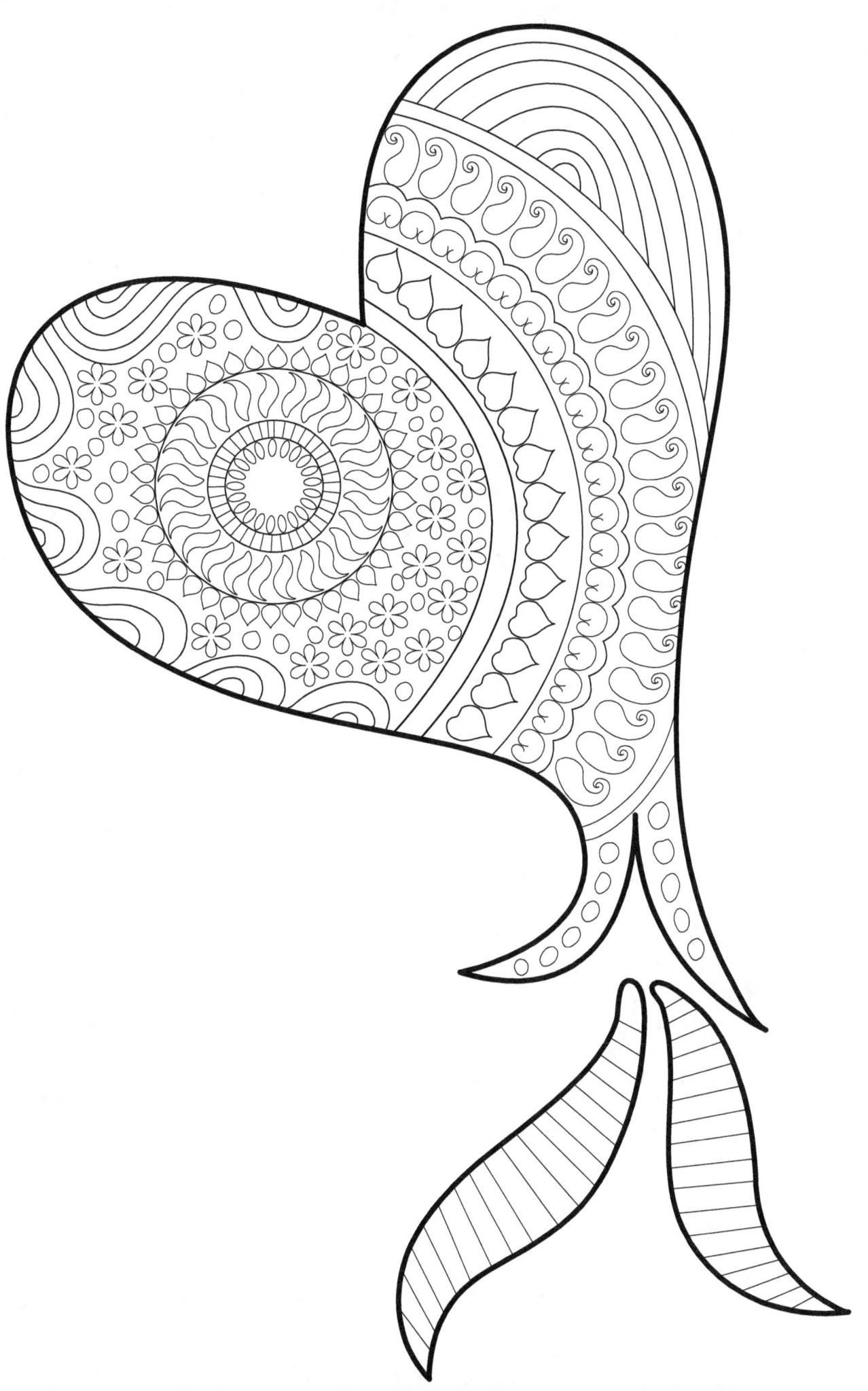

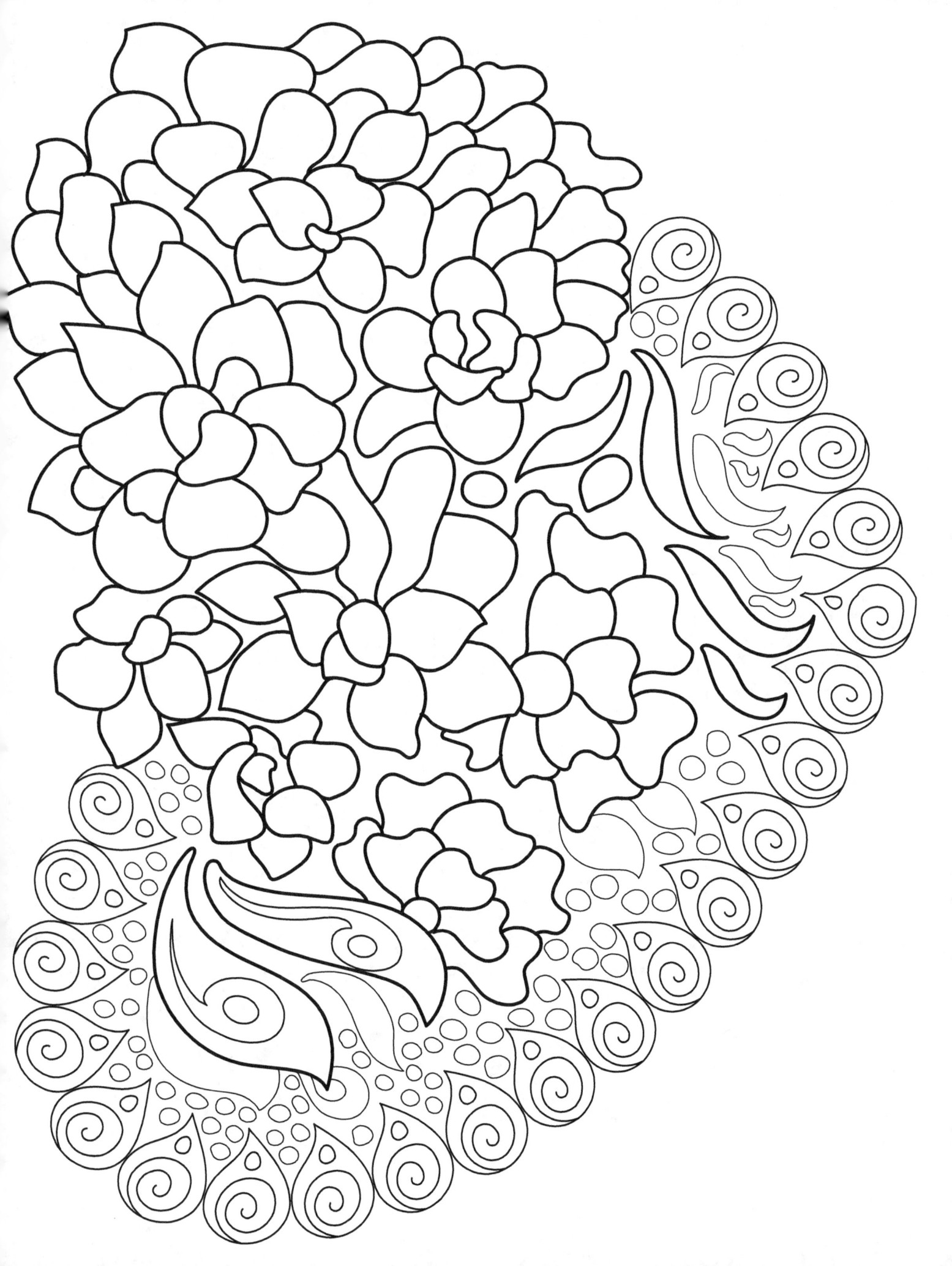

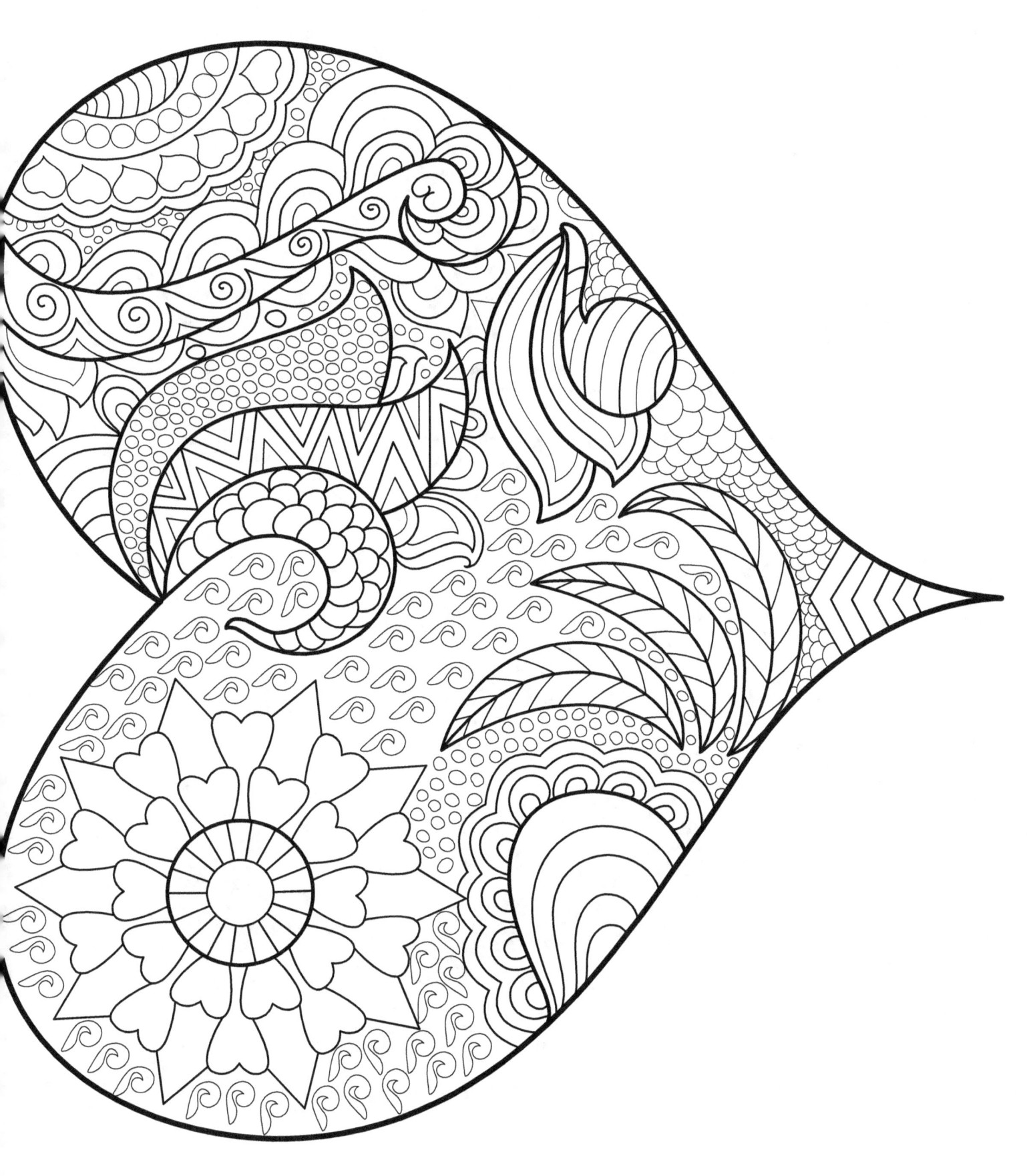

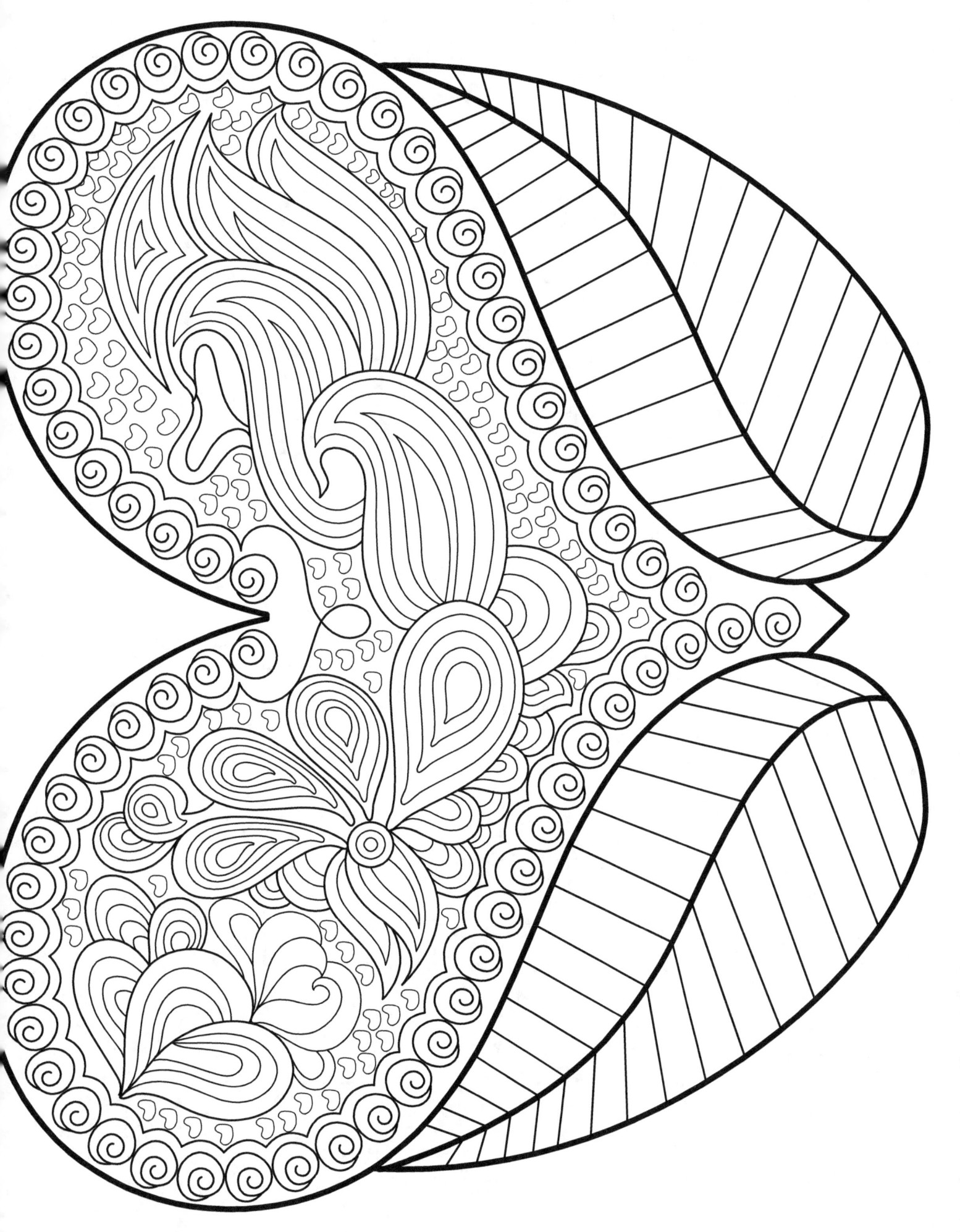

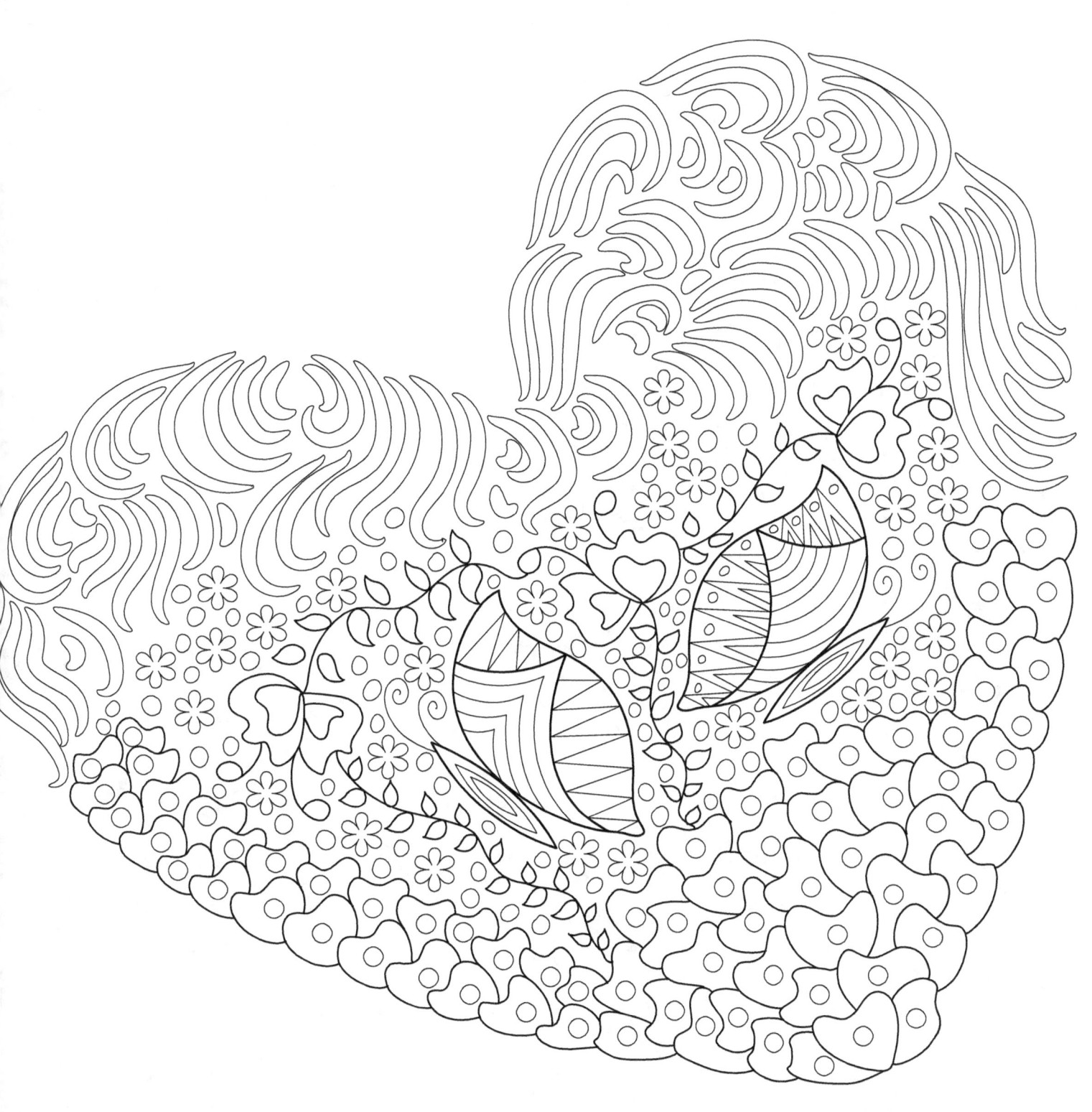

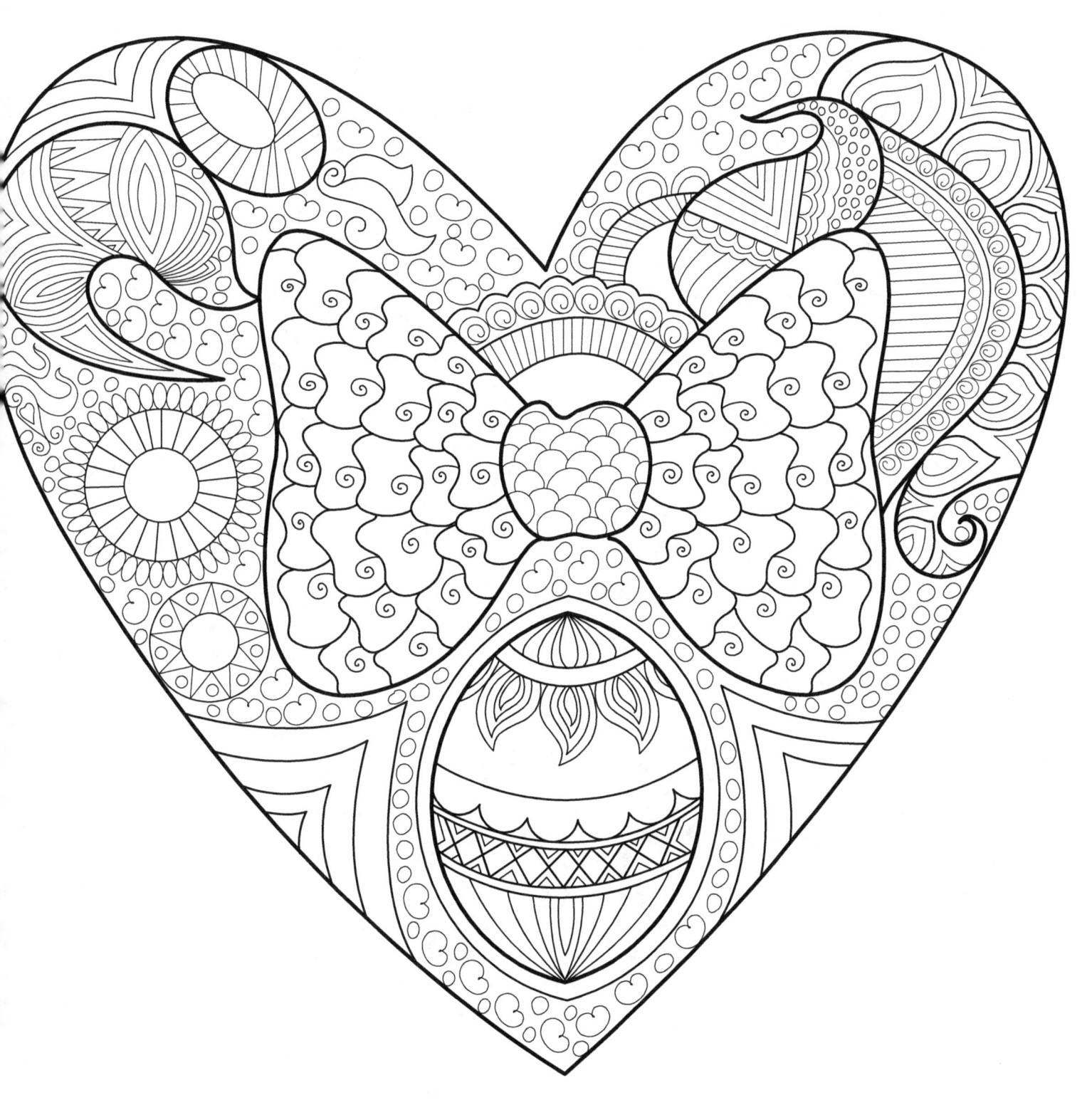

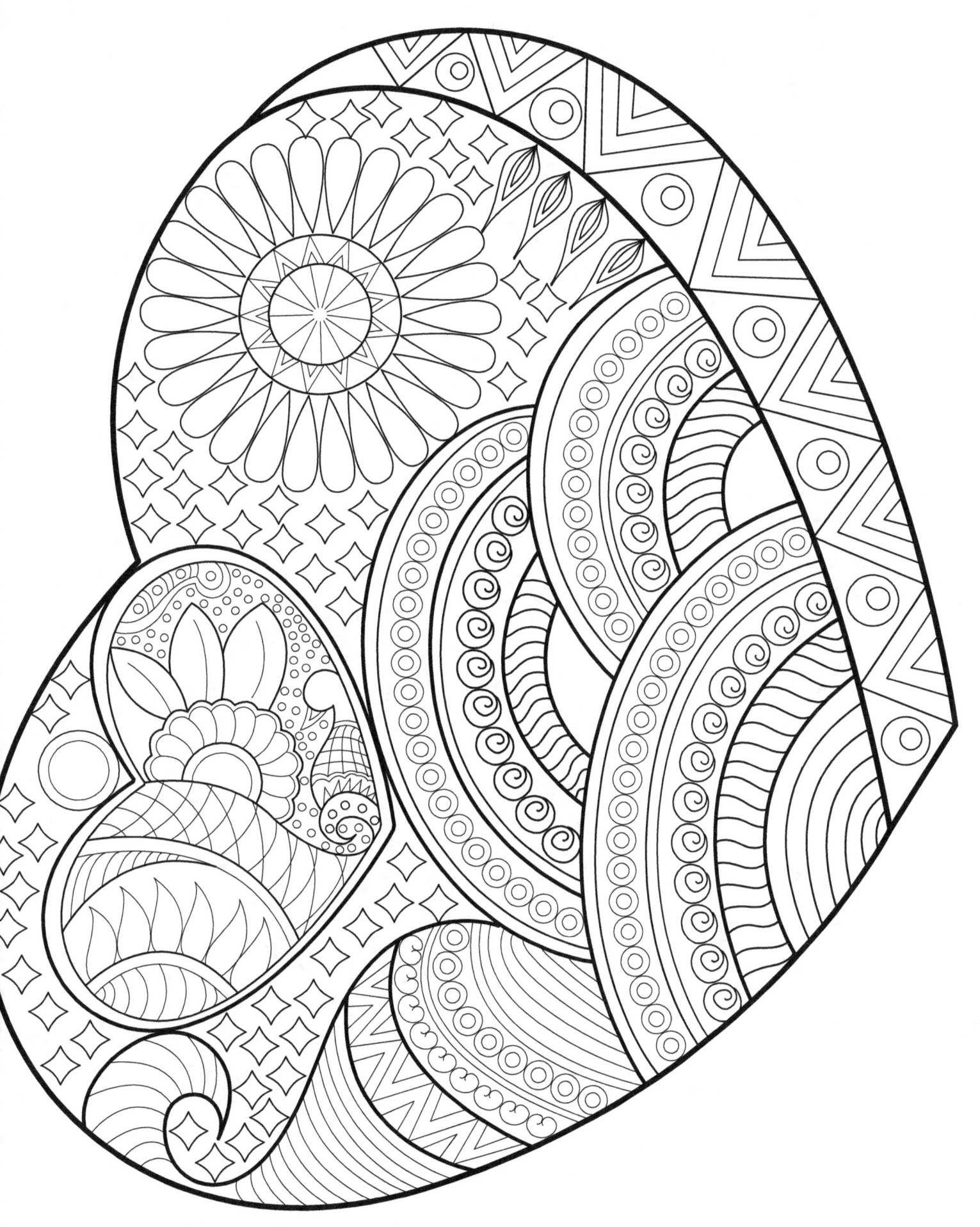

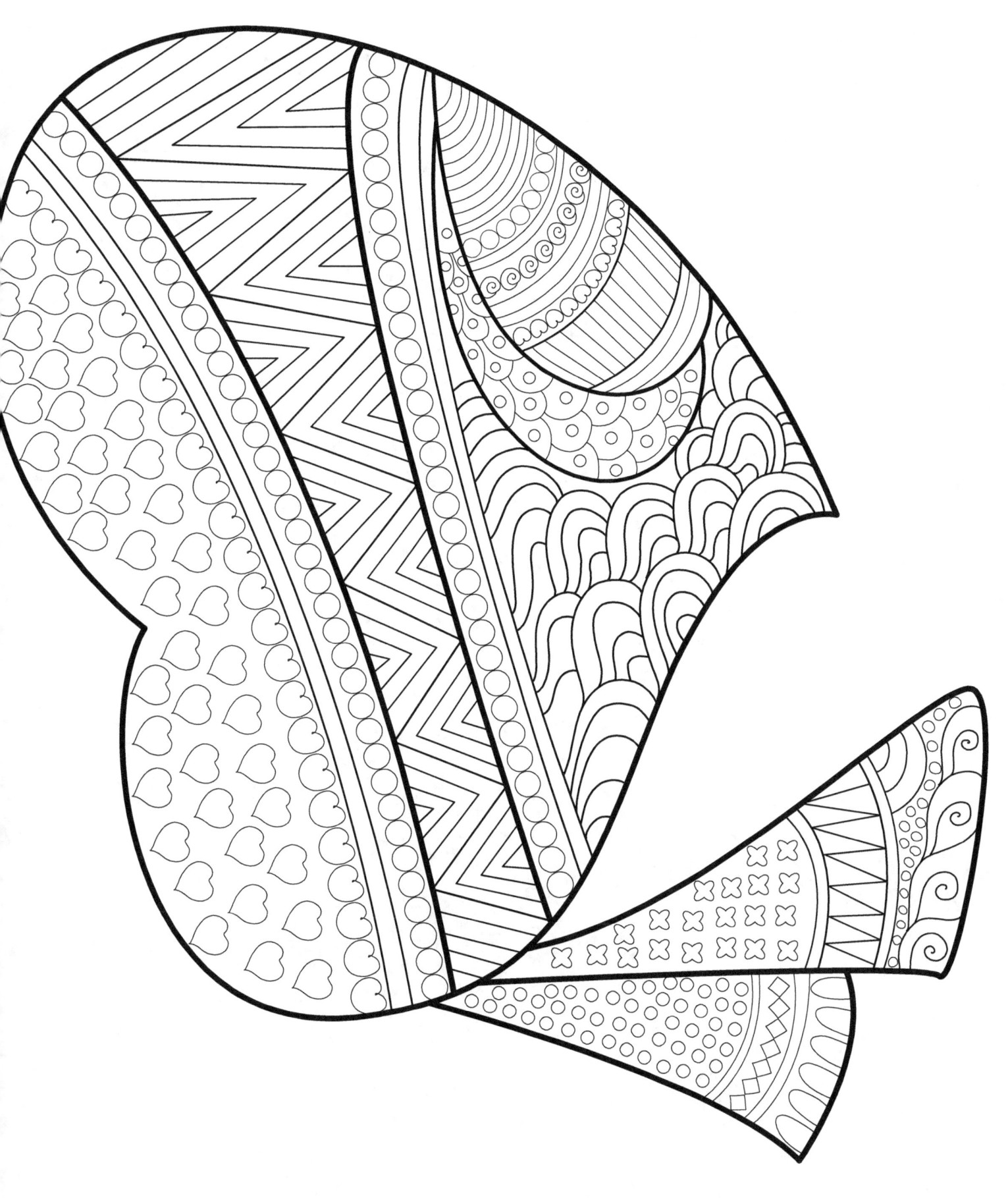

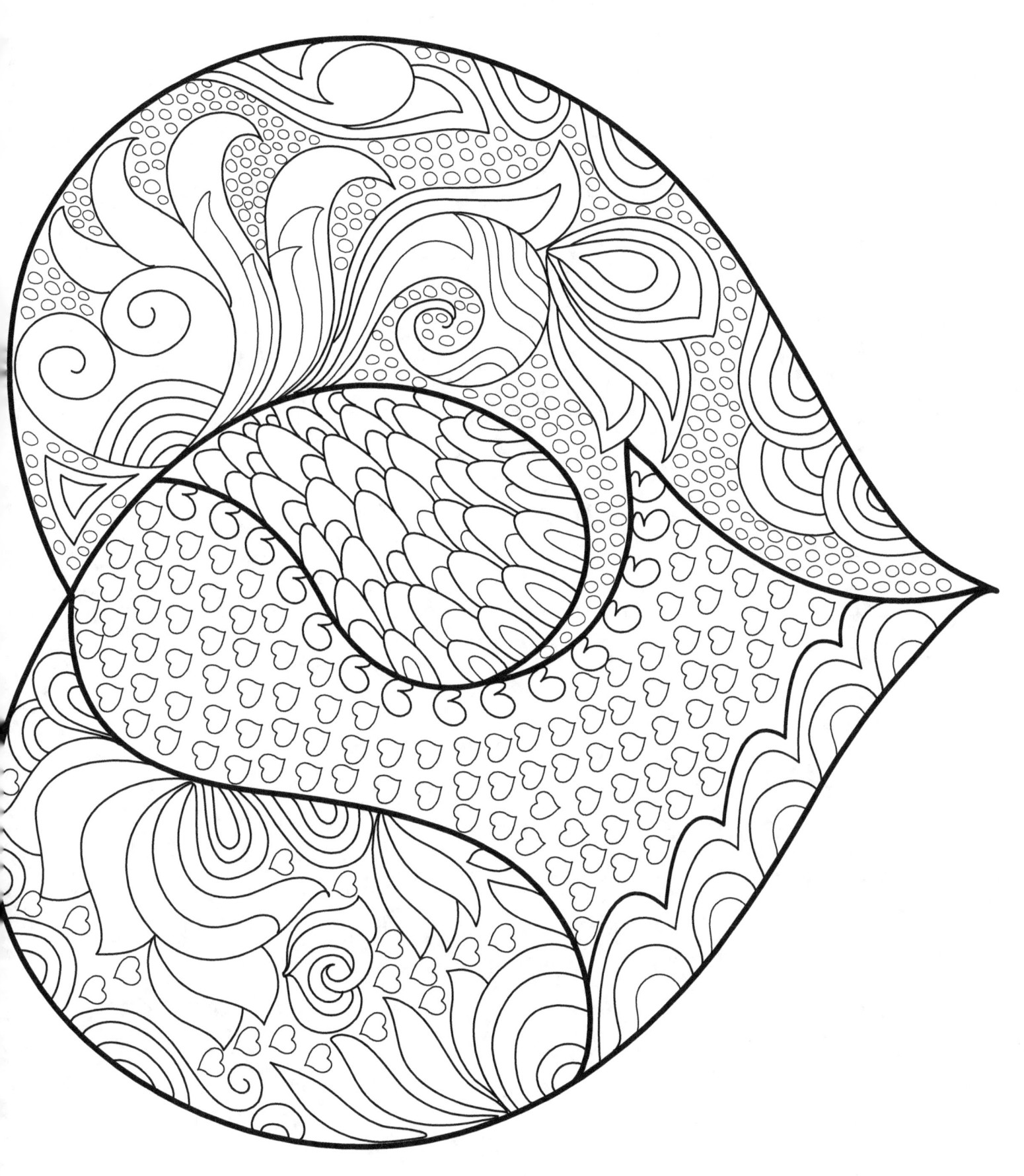

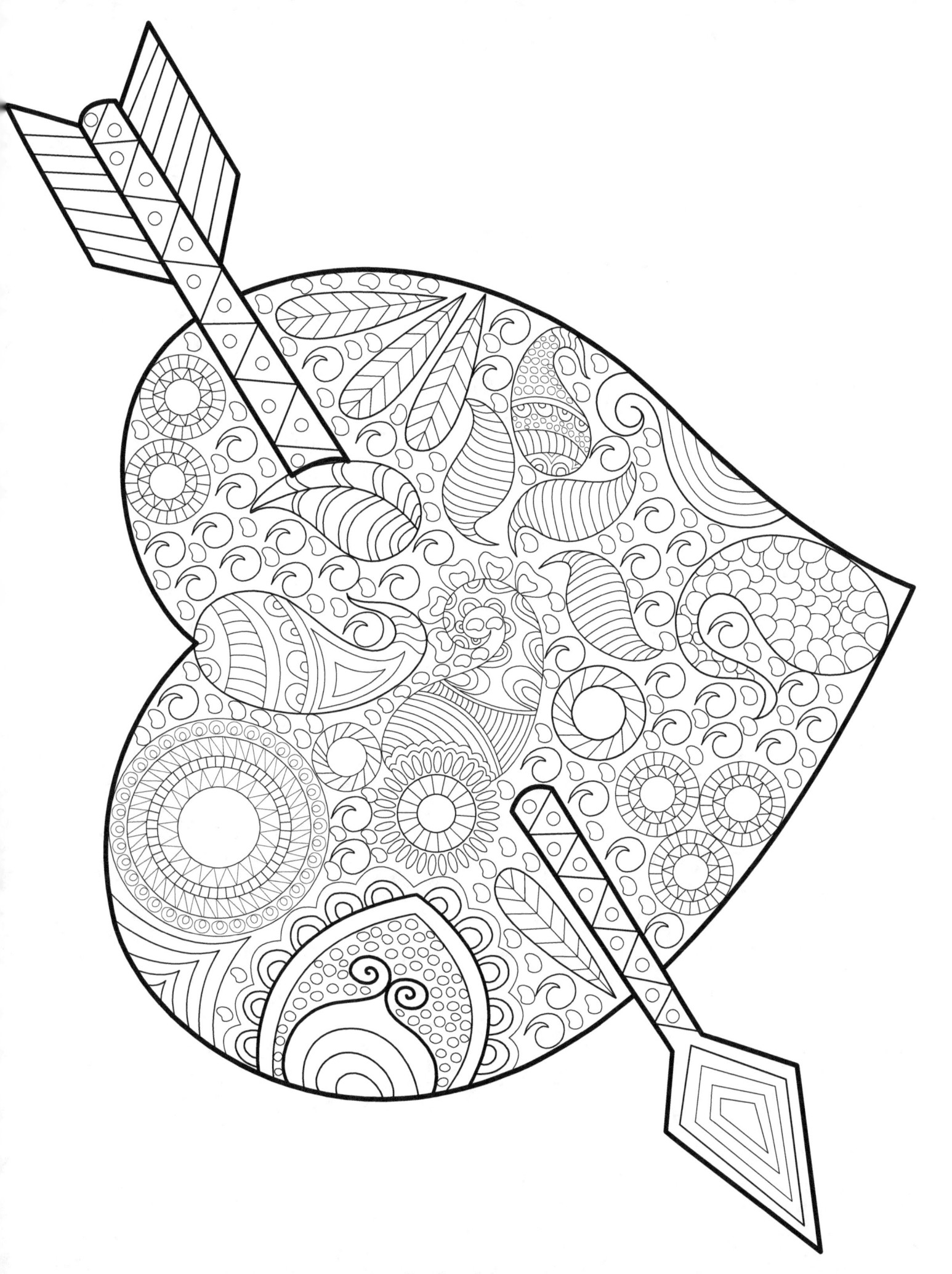

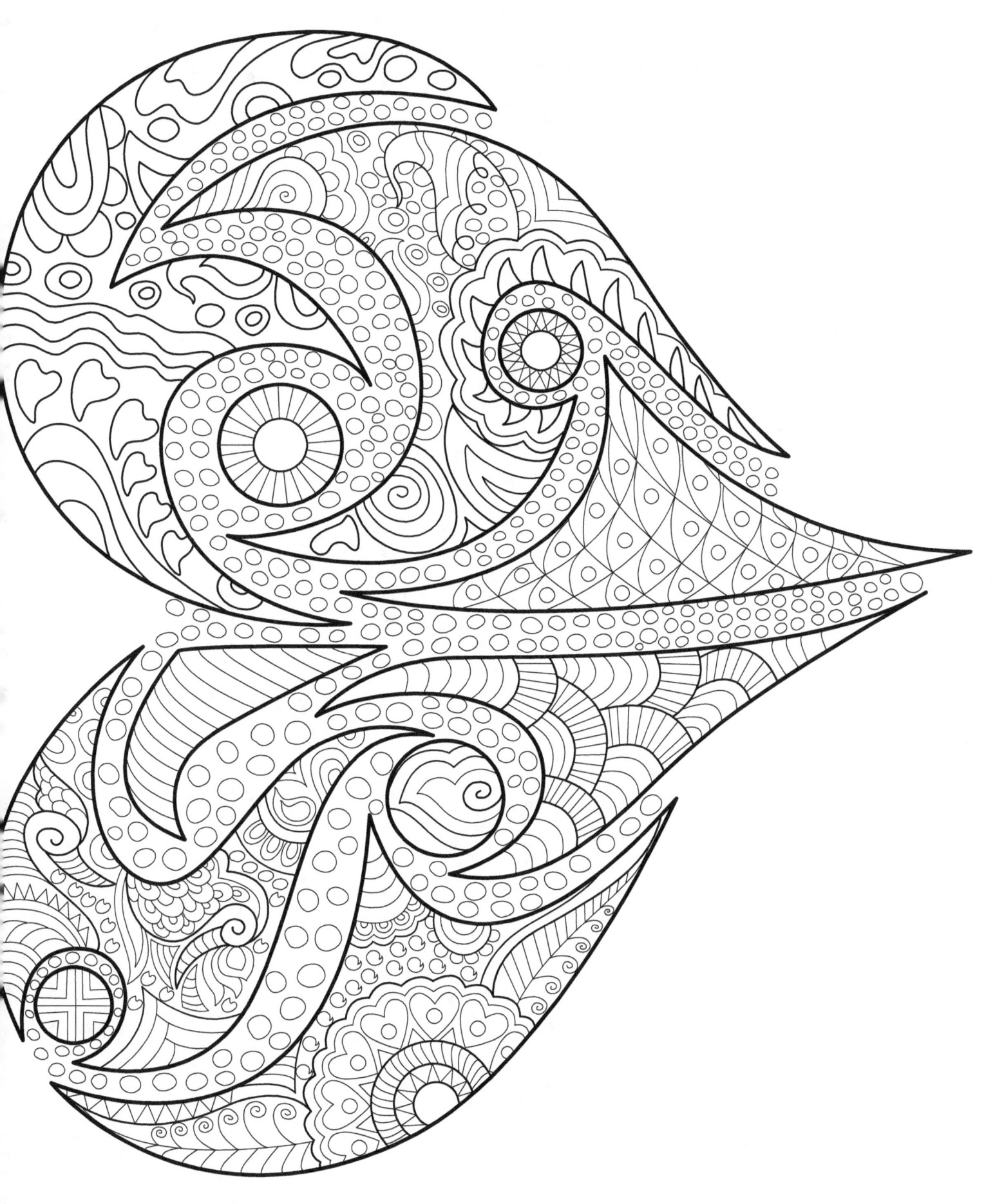

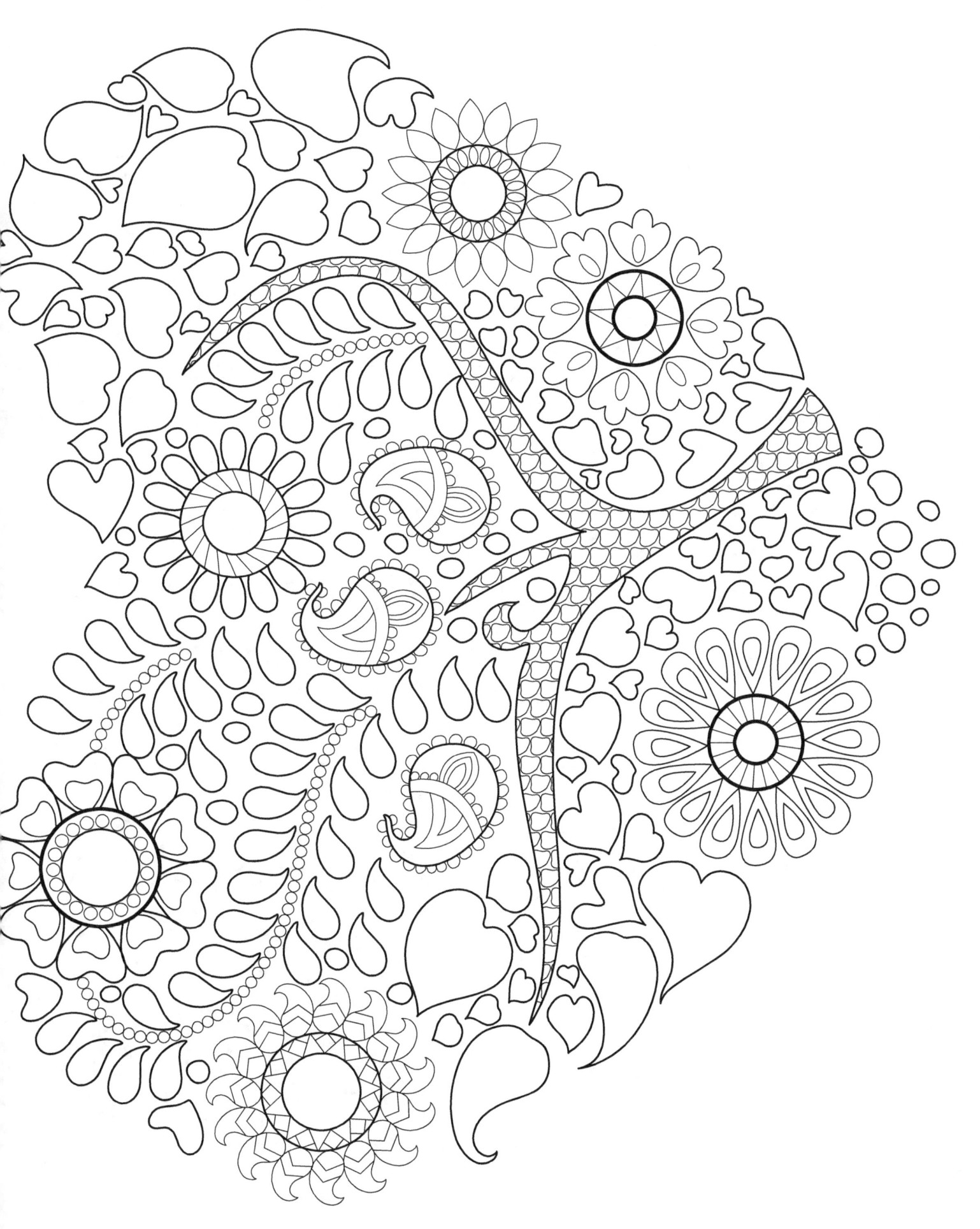

MAZE

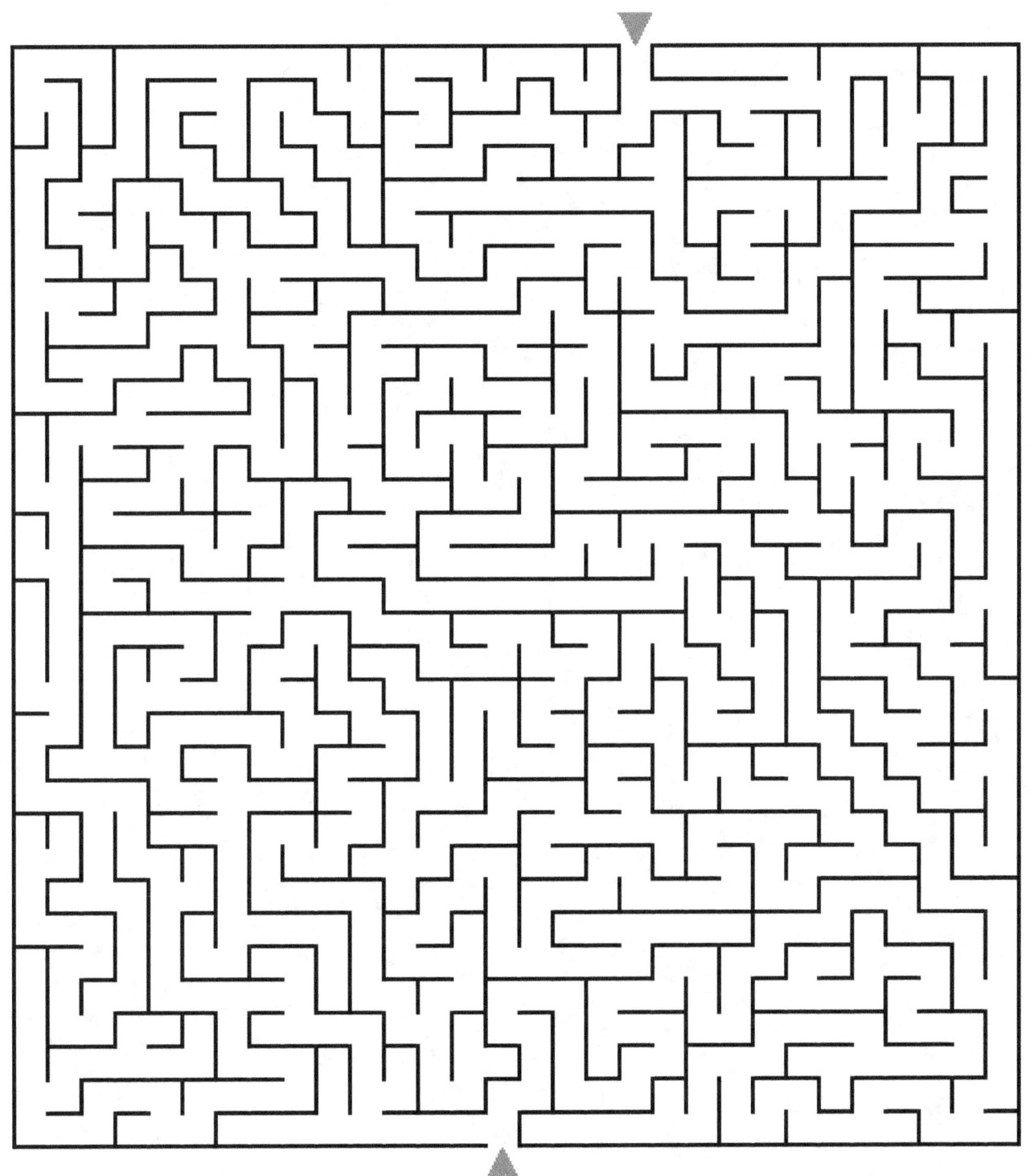

COLOR CHARTS

Solution

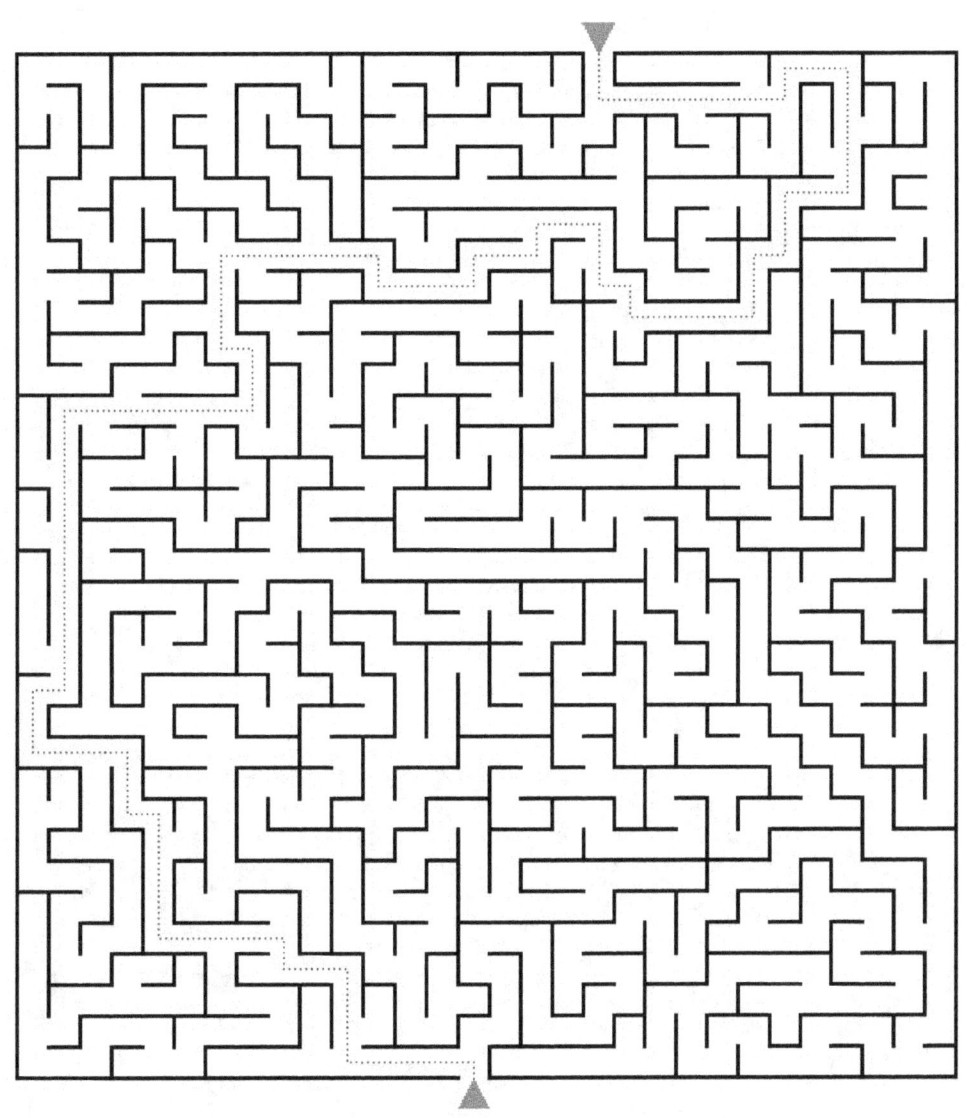

www.ingramcontent.com/pod-product-compliance
Lightning Source LLC
Chambersburg PA
CBHW081453220526
45466CB00008B/2619